NAY RATHER

ANNE CARSON

Nay Rather

The Cahiers
Series

CENTER FOR WRITERS & TRANSLATORS
THE AMERICAN UNIVERSITY OF PARIS

SYLPH EDITIONS

> Each something is a celebration of
> the nothing that supports it.
>
> John Cage

Silence is as important as words in the practice and study of translation. This may sound like a cliché. (I think it is a cliché. Perhaps we can come back to cliché.) There are two kinds of silence that trouble a translator: physical, metaphysical. Physical silence happens when you are looking at, say, a poem of Sappho's inscribed on a papyrus from two thousand years ago that has been torn in half. Half the poem is empty space. A translator can signify or even rectify this lack of text in various ways – with blankness or brackets or textual conjecture – and she is justified in doing so because Sappho did not intend that part of the poem to fall silent. Metaphysical silence happens inside words themselves. And its intentions are harder to define. Every translator knows the point where one language cannot be rendered into another. Take the word cliché. Cliché is a French borrowing, past participle of the verb *clicher*, a term from printing meaning 'to make a stereotype from a relief printing surface'. It has been assumed into English unchanged, partly because using French words makes English-speakers feel more intelligent and partly because the word has imitative origins (it is supposed to mimic the sound of the printer's die striking the metal) that make it untranslatable. English has different sounds. English falls silent. This kind of linguistic decision is simply a measure of foreignness, an acknowledgment of the fact that languages are not algorithms of one another, you cannot match them item for item. But now what if, within this silence, you discover a deeper one – a word that does not *intend* to be translatable. A word that stops itself. Here is an example.

In the fifth book of Homer's *Odyssey*, when Odysseus is about to confront a witch named Kirke whose practice is to turn men into pigs, he is given by the god Hermes a pharmaceutical plant to use against her magic. Here is Homer's description of it:

9.4 They put stones in their eye sockets. Upper class people put precious stones.

16.2 Prior to the movement and following the movement, stillness.

8.0 Not sleeping made the Cycladic people gradually more and more brittle. Their legs broke off.

1.0 The Cycladic was a neolithic culture based on emmer wheat, wild barley, sheep, pigs and tuna speared from small boats.

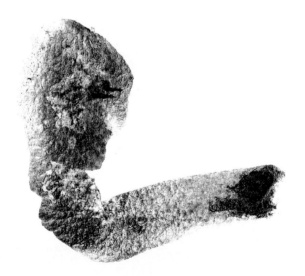

ὣς ἄρα φωνήσας πόρε φάρμακον Ἀργεϊφόντης.
ἐκ γαίης ἐρύσας καί μοι φύσιν αὐτοῦ ἔδειξε.
ῥίζῃ μὲν μέλαν ἔσκε, γάλακτι δὲ εἴκελον ἄνθος·
μῶλυ δέ μιν καλέουσι θεοί, χαλεπὸν δέ τ' ὀρύσσειν
ἀνδράσι γε θνητοῖσι· θεοὶ δέ τε πάντα δύνανται.

So speaking Hermes gave him the drug
 by pulling it out of the ground and he showed the
 nature of it:
 at the root it was black but like milk was the flower.
 Μῶλυ (*mōlu*) is what the gods call it. And it is very
 hard to dig up
 for mortal men. But gods can do such things.
 (10.302-6).

Μῶλυ (*mōlu*) is one of several allusions in Homer's poems to a
language apparently known only to gods. Linguists like to see
in these names traces of some older layer of Indo-European
preserved in Homer's Greek. However that may be, when he
invokes the language of gods Homer usually tells you the earthly
translation also. Here he does not. He wants this word to fall
silent. Here are four letters of the alphabet, you can pronounce
them but you cannot define, possess, or make use of them. You
cannot search for this plant by the roadside or google it and
find out where to buy some. The plant is sacred, the knowledge
belongs to gods, the word stops itself. Almost as if you were
presented with a portrait of some person – not a famous person
but someone you might recognize if you put your mind to it –
and as you peer closely you see, in the place where the face should
be, a splash of white paint. Homer has splashed white paint not
on the faces of his gods but on their word. What does this word
hide? We will never know. But that smudge on the canvas does
serve to remind us of something important about these puzzling
beings, the gods of epic, who are not consistently bigger, stronger,
smarter, nicer or better-looking than humans, who are in fact
anthropomorphic clichés from top to bottom, yet who do have
one escapade up their sleeve – immortality. They know how not to
die. And who can say but the four untranslatable letters of Μῶλυ
(*mōlu*) might be the place where that knowledge is hidden.

11.4 Left hand on Tuesdays, right hand on Wednesdays.

10.1 She plied the ferryboat back and forth, island to
 island, navigating by means of her inner eye.

9.0 When their faces wore smooth they painted them
 back on with azurite and iron ore.

12.1 All this expertise just disappears when a people
 die out.

There is something maddeningly attractive about the untranslatable, about a word that goes silent in transit. I want to explore some examples of this attraction, at its most maddened, from the trial and condemnation of Joan of Arc.

Joan of Arc's history, especially the historical record of her trial, is one fraught with translation at every level. She was captured in battle on 23 May 1430. Her trial lasted from January to May of 1431 and entailed a magistrate's inquest, six public interrogations, nine private interrogations, an abjuration, a relapse, a relapse trial, and condemnation. Her death by fire took place on 30 May 1431. Thousands of words went back and forth between Joan and her judges during the months of her inquisition; many of them are available to us in some form. But Joan herself was illiterate. She spoke Middle French at her trial, whose minutes were transcribed by a notary and later translated into Latin by one of her judges. This process involved not only the transposition of Joan's direct responses into indirect speech and of her French idioms into the Latin of juridical protocol, but also deliberate falsification of some of her answers in such a way as to justify her condemnation (this criminal intervention was revealed at a retrial that took place twenty-five years after her death). Yet these many layers of official distance separating us from what Joan said are just an after-effect of the one big original distance that separates Joan herself from her sentences.

All Joan's guidance, military and moral, came from a source she called 'voices'. All the blame of her trial was gathered up in this question, the nature of the voices. She began to hear them when she was twelve years old. They spoke to her from outside, commanding her life and death, her military victories and revolutionary politics, her dress code and heretical beliefs. During the trial Joan's judges returned again and again to this crux: they insisted on knowing the story of the voices. They wanted her to name, embody, and describe them in ways they could understand, with recognizable religious imagery and emotions, in a conventional narrative that would be susceptible to conventional disproof. They framed this desire in dozens of ways, question after question. They prodded and poked and hemmed her in. Joan despised the line of inquiry and blocked it as long as she could. It seems that for her the voices had no story. They were an

2.0 They wore their faces smooth with trying to sleep,
 they ground their lips and nipples off in the distress
 of pillows.

4.4 How you spear it, how you sheer it, how you flense
 it, how you grind it, how you get it to look so
 strangely relaxed.

4.0 Mirrors led the Cycladic people to think about the
 soul and to wish to quiet it.

1.1 The boats had up to 50 oars and small attachments
 at the bow for lamps. Tuna was fished at night.

experienced fact so large and real it had solidifed in her as a sort of sensed abstraction – what Virginia Woolf (in *To the Lighthouse*) called 'that very jar on the nerves before it has been *made* anything'. Joan wanted to convey the jar on the nerves without translating it into theological cliché. It is her rage against cliché that draws me to her. A genius is in her rage. We all feel this rage at some level, at some time. The genius answer to it is catastrophe.

I say catastrophe is an answer because I believe cliché is a question. We resort to cliché because it's easier than trying to make up something new. Implicit in it is the question, Don't we already know what we think about this? Don't we have a formula we use for this? Can't I just send an electronic greeting card or Photoshop a picture of what it was like rather than trying to come up with an original drawing? During the five months of her trial Joan persistently chose the term 'voice' to describe how God guided her. She did not spontaneously claim that the voices had bodies, faces, names, smell, warmth or mood, nor that they entered the room by the door, nor that when they left she felt sad. Under the inexorable urging of her inquisitors she gradually added all these details. But the storytelling effort was clearly hateful to her and she threw white paint on it wherever she could, giving them responses like:

> ... You asked that before. Go look at the record.
> ... Pass on to the next question, spare me.
> ... I knew that well enough once but I forget.
> ... That does not touch your process.
> ... Ask me next Saturday.

And on 24 February 1430, when the judges were pressing her to define the voices as singular or plural, she most wonderfully said (as a sort of summary of the problem):

> The light comes in the name of the voice (*in nomine vocis venit claritas*).

The light comes in the name of the voice is a sentence that stops itself. Its components are simple yet it stays foreign, we cannot own it. Like Homer's untranslatable *mōlu* it seems to come from

16.0 As far as the experience of stirring is concerned, small stillness produces small stirring and great stillness great stirring.

3.3 A final theory is that you could fill the pan with water and use it as a mirror.

2.1 It was no use. They'd lost the knack. Sleep was a stranger.

somewhere else and it brings a whiff of immortality with it. We
know that in Joan's case this turned out to be a whiff of herself
burning. Let's pass on to a less dire example of translation,
but one that is equally driven by the rage against cliché – or, as
the translator himself in this case puts it – 'I want to paint the
scream not the horror'. This you may recognize as a statement
of the painter Francis Bacon, talking about his well-known series
of portraits of the pope screaming (which are variations on a
portrait of Pope Innocent X by Velázquez).[1]

Now Francis Bacon is someone who subjected himself to
inquisition repeatedly throughout his career, most notably in
a series of interviews with art critic David Sylvester, which are
published in a volume called *The Brutality of Fact*. 'The brutality
of fact' is Bacon's own phrase for what he is after in a painting.
He is a representational painter. His subjects are birds, dogs,
grass, people, sand, water, himself, and what he wants to capture
of these subjects is (he says) their 'reality' or (once he used the
term) 'essence' or (often) 'the facts'. By 'facts' he doesn't mean to
make a copy of the subject as a photograph would, but rather to
create a sensible form that will translate directly to your nervous
system the same sensation as the subject. He wants to paint the
sensation of a jet of water, that very jar on the nerves. Everything
else is cliché. Everything else is the same old story of how Saint
Michael or Saint Margaret or Saint Catherine came in the door
with a thousand angels around them and a sweet smell filled the
room. He hates all that storytelling, all that illustration, he will
do anything to deflect or disrupt the boredom of storytelling,
including smudge the canvas with sponges or throw paint at it.

Francis Bacon does not invoke the metaphor of translation
when he describes what he wants to do to your nerves by means
of paint, but he does at times literally arrive at silence, as when
he says to his interviewer, 'You see this is the point at which one
absolutely cannot talk about painting. It's in the process'.[2] In this
statement he is making a territorial claim for the untranslatable,
as Joan of Arc did when she said to her judges, 'That does not
touch your process'. Two different senses of 'process' but the
same exasperated shrug toward an authority whose demands are
unrealistic. One can sense this exasperation shaping Joan's public
life – her military recklessness, her choice of men's clothing,

14.1 There it was plunging up and down in its shallow holes.

6.1 The handbag, that artifact which freed human beings from having to eat food wherever they found it.

3.0 While staying up at night the Cycladic people invented the frying pan.

her abjuration of heresy, her relapse into heresy, her legendary
final words to the judges: 'Light your fires!' Had silence been a
possibility for her, Joan would not have ended up in the fires. But
the inquisitors' method was to reduce everything she had said to
twelve charges in their Latin language and their own wording.
That is to say, their story of her solidified as the fact of the matter.[3]
The charges were read out to her. She had to answer each with
'Yes I believe it' or 'No I believe it not'. A yes or no question
forbids a word to stop itself. Untranslatability is illegal.

Stops and silence of various kinds, however, seem to be
available to Francis Bacon within the process of his painting. For
instance in his subject matter, when he chooses to depict people
screaming in a medium that cannot transmit sound. Or in his use
of colour, or more precisely his use of the edges of the colour. His
aim as a painter, as we have seen, is to grant sensation without the
boredom of its conveyance. He wants to defeat narrative wherever
it seeks to arise, which is pretty much everywhere since humans
are creatures who crave a story. There is a tendency for story to
slip into the space between any two figures or any two marks
on a canvas. Bacon uses colour to silence this tendency. He pulls
colour right up to the edge of his figures – a colour so hard, flat,
bright, motionless, it is impossible to enter into it or wonder about
it. There is a desolation of curiosity in it. He once said to David
Sylvester that he'd like to 'put a Sahara desert or the distances
of a Sahara' in between parts of a painting. His colour has an
excluding and accelerating effect, it makes your eye move on. It's a
way of saying, Don't linger here and start thinking up stories, just
stick to the facts. Sometimes he puts a white arrow on top of the
colour to speed your eye and denounce storytelling even more.
To look at this arrow is to feel an extinguishing of narrative. He
says he got the idea for the arrows from a golf manual.[4] To know
this makes me feel even more hopeless about understanding the
story of his picture. Bacon has no interest in encouraging such
hope; nor did Joan of Arc when her inquisitors asked 'What do
your voices sound like?' and she answered 'Ask me next Saturday'.
Bacon extinguishes the usual relation of figure to ground, the
usual passage of information at that place, as Joan extinguishes the
usual relation of question to answer. They put a stop on the cliché.

11.0 Three times a day she put the boat on autopilot
 and went down below to the cool silent pantry.

7.1 Abstention from grain is helpful.

9.3 Their eyes fell out.

11.3 The food was tastier that way.

11.5 This may sound to you like a mere boyish stunt.

Bacon has another term for this stopping: he calls it 'destroying clarity with clarity'.[5] Not just in his use of colour but in the whole strategy of his compositions, he wants to make us see something we don't yet have eyes for, to hear something that was never sounded. He goes inside clarity to a place of deeper refreshment, where clarity is the same and yet differs from itself, which may be analogous to the place inside a word where it falls silent in its own presence. And it is noteworthy that for Bacon this is a place of violence. He talks a lot about violence in his interviews. He gets asked a lot about violence in his interviews. He and his interviewers do not mean the same thing by this word. Their question is about images of crucifixion, slaughtered meat, twisting, mangling, bullfights, glass cages, suicide, half-animals and unidentifiable flesh. His answer is about reality. He is not interested in illustrating violent situations and disparages his own works that do so as 'sensational'. He wants to convey the sensation not the sensational, to paint the scream not the horror. And he understands the scream in its reality to lie somewhere inside the surface of a screaming person or a scream-worthy situation. If we consider his study of the pope screaming alongside the painting that inspired it, Velázquez's *Portrait of Innocent X*, we can see what Bacon has done is to plunge his arms into Velázquez's image of this profoundly disquieted man and to pull out a scream that is already going on there deep inside. He has made a painting of silence in which silence silently rips, as black holes are said to do in deep space when no one is looking. Here is Bacon speaking to David Sylvester:

> When talking about the violence of paint it's nothing to do with the violence of war. It's to do with an attempt to remake the violence of reality itself ... and the violence also of the suggestions within the image itself which can only be conveyed through paint. When I look at you across the table I don't only see you, I see a whole emanation which has to do with personality and everything else ... the living quality ... all the pulsations of a person ... the energy within the appearance And to put that over in a painting means that it

11.1 The pantry, what a relief after the splash and glare of the helm.

4.1 To uncontrive.

6.0 To the Cycladic people is ascribed the invention of the handbag

3.1 Quite a number of frying pans have been found by archaeologists. The frying pans are small. No one was very hungry at night.

would appear violent in paint. We nearly always
live through screens – a screened existence. And
I sometimes think when people say my work is
violent that from time to time I have been able to
clear away one or two of the screens.[6]

Bacon says we live through screens. What are these screens? They
are part of our normal way of looking at the world, or rather our
normal way of seeing the world without looking at it, for Bacon's
claim is that a real seer who looked at the world would notice it
to be fairly violent – not violent as narrative surface but somehow
violently composed underneath the surface, having violence as
its essence. No one has ever seen a black hole yet scientists feel
confident they can locate its essence in the gravitational collapse
of a star – this massive violence, this *something* which is also,
spectacularly, *nothing*. But let us now shift our historical gaze
to Germany at the turn of the eighteenth century and give our
attention to a lyric poet of that time, who disappeared into his
own black hole while trying to translate the colour purple.

Our English word 'purple' comes from Latin *purpureus*,
which comes from Greek πορφύρα (*porphura*), a noun denoting
the purplefish. This sea mollusc, properly the purple limpet or
murex, was the source from which all purple and red dyes were
obtained in antiquity. But the purplefish had another name in
ancient Greek, namely κάλχη (*kalkhē*), and from this word was
derived a verb and a metaphor and a problem for translators.
The verb καλχαίνειν (*kalkhainein*), 'to make purple', came to
signify profound and troubled emotion: to grow dark with
disquiet, to seethe with worries, to harbour dark thoughts, to
brood in the deep of one's mind. When the German lyric poet
Friedrich Hölderlin undertook to translate Sophokles' *Antigone*
in 1796, he met this problem on the first page. The play opens
with a distressed Antigone confronting her sister Ismene. 'What
is it?' asks Ismene, then she adds the purple verb. 'You are
obviously growing dark in mind, brooding deeply (καλχαίνουσ'/
kalkhainous') over some piece of news'. This is a standard
rendering of the line. Hölderlin's version: *Du scheinst ein rotes
Wort zu färben,* would mean something like 'You seem to colour a
reddish purple word, to dye your words red-purple'. The deadly

9.1 Did I mention the marble pillows, I think I did.

2.3 This became a Cycladic proverb.

5.2 Proust liked a good jolt.

7.2 Abstention from grain is the same for men and
 women. You put your lungs in an extraordinary
 state of clear coolness.

literalism of the line is typical of him. His translating method was
to take hold of every item of the original diction and wrench it
across into German exactly as it stood in its syntax, word order,
and lexical sense. The result was versions of Sophokles that
made Goethe and Schiller laugh aloud when they heard them.
Learned reviewers itemized more than one thousand mistakes
and called the translations disfigured, unreadable, the work of a
madman. Indeed by 1806 Hölderlin was certified insane. His family
committed him to a psychiatric clinic, from which after a year he
was released as incurable. He spent the remaining thirty-seven
years of his life in a tower overlooking the river Neckar, in varying
states of indifference or ecstasy, walking up and down his room,
playing the piano, writing on scraps of paper, receiving the odd
visitor. He died still insane in 1843. It is a cliché to say Hölderlin's
Sophokles translations show him on the verge of breakdown and
derive their luminous, gnarled, unpronounceable weirdness from
his mental condition. Still I wonder what exactly is the relation
of madness to translation? Where does translation happen in
the mind? And if there is a silence that falls inside certain words,
when, how, with what violence does that take place, and what
difference does it make to who you are?

One thing that strikes me about Hölderlin as a translator, and
about Francis Bacon as a painter, and for that matter about Joan
of Arc as a soldier of God, is the high degree of self-consciousness
that is present in their respective manipulations of catastrophe.
Hölderlin had begun to be preoccupied with translating Sophokles
in 1796 but did not publish *Oedipus* and *Antigone* until 1804. Judging
his first versions 'not lively (*lebendıg*) enough', he subjected them
to years of compulsive revision, forcing the texts from strange to
more strange. Here is Hölderlinian scholar David Constantine's
description of this effort:

> He warped the original to fit his own idiosyncratic
> understanding not only of it but also of his
> obligation in translating it... Choosing always the
> more violent word, so that the texts are stitched
> through with the vocabulary of excess... he was also
> voicing those forces in his own psychology which,
> very soon, would carry him over the edge. And in

13.0 One night there was a snowfall, solitary, absurd.

6.3 And after dinner, harps.

1.2 The Cycladic was an entirely insomniac culture.

2.2 Well, they said, these are the pies we have. It was
 a proverb.

uttering them did he not aid and abet them? It is the old paradox: the better the poet says these things, the better he arms them against himself. So well put, are they not irresistible?[7]

Irresistible at least was the process of this violence. For it is remarkable that Hölderlin began at this time to revise also his own early work and he went about it the same way, that is, he would scrutinize finished poems for the 'not living/lively enough' parts then translate these into some other language, also German, that lay silent inside his own. As if he were moving along a line ripping the lids off words and plunging his arms in, he met his madness coming the other way.

Yet it was not altogether a chance meeting. From early on Hölderlin had a theory of himself. This from a letter to his friend Neuffer in 1798, which begins with the sentence, '"liveliness/ livingness" (*Lebendigkeit*) in poetry is now what most preoccupies my mind', then goes on to this lucid analysis of his own balance of being:

> because I am more destructible than some other
> men, I must seek all the more to derive some
> advantage from what has a destructive effect on
> me...I must accept it in advance as indispensable
> material, without which my most inward being
> cannot ever entirely present itself. I must assimilate
> it, arrange it...as shadows to my light...as
> subordinate tones among which the tone of my soul
> springs out all the more livingly.[8]

This from a letter to Hölderlin's mother from his friend Sinclair in 1804:

> I am not the only one – there are six or eight
> people besides me who have met Hölderlin and
> are convinced that what appears to be mental
> derangement is in fact nothing of the sort but is
> rather a manner of expressing himself which he
> has deliberately adopted for very cogent reasons.[9]

4.2 My point of view is admittedly faulty. My nose is always breathing. I am worn out with breathing. I suspect you have days when you choose not to breathe at all.

14.0 That was the night she looked to her soul.

3.2. Or they may have been prestige frying pans.

9.2 They painted wonderful widow's peaks on themselves or extra breasts.

This from an 1804 review of his Sophokles translations:

> What do you make of Hölderlin's Sophokles? Is the
> man mad or does he just pretend or is his Sophokles
> a veiled satire on bad translators?[10]

Maybe Hölderlin was pretending to be mad the whole time,
I don't know. What fascinates me is to see his catastrophe,
at whatever level of consciousness he chose it, as a method
extracted from translation, a method organized by the rage
against cliché. After all what else is one's own language but a
gigantic cacophonous cliché. Nothing has not been said before.
The templates are set. Adam long ago named all the creatures.
Reality is captured. When Francis Bacon approaches a white
canvas, its empty surface is already filled with the whole history
of painting up to that moment, it is a compaction of all the
clichés of representation already extant in the painter's world, in
the painter's head, in the probability of what can be done on this
surface. Screens are in place making it hard to see anything but
what one expects to see, hard to paint what isn't already there.
Bacon is not content to deflect or beguile cliché by some painterly
trick, he wants (as Gilles Deleuze says in his book about Bacon)
to 'catastrophize' it right there on his canvas. So he makes what
he calls 'free marks' on the canvas, both at the beginning when
it is white and later when it is partly or completely painted. He
uses brushes, sponges, sticks, rags, his hand, or just throws a can
of paint at it. His intention is to disrupt its probability and to
shortcircuit his own control of the disruption. His product is a
catastrophe, which he will then proceed to manipulate into an
image that he can call *real*. Or he may just hang it up:

DAVID SYLVESTER:
> You would never end a painting by suddenly
> throwing something at it. Or would you?

FRANCIS BACON:
> Oh yes. In that triptych on the shoulder of the figure
> being sick into the basin, there's a whip of white
> paint that goes like that. Well I did that at the very
> last moment and I just left it.[11]

5.1 Possibly because of his blanket refusal to listen to another person's dreams at the breakfast table, for Proust dismissed this type of recollection as 'mere anamnesia'.

16.1 There it lay, the foredeck in the moonlight, more silver than the sea.

9.5 Perhaps now they were glad after all that they did not sleep.

5.3 That moment when everyone sees exactly what is on the end of their fork, as William S. Burroughs said of celebrity.

Free marks are a gesture of rage. One of the oldest myths we have of this gesture is the story of Adam and Eve in the garden of paradise. Eve changes human history by putting a free mark on Adam's apple. Why does she do this? To say she was seduced by the snake or longing for absolute knowledge or in search of immortality are possible answers. On the other hand maybe she was catastrophizing. Adam had just performed the primordial act of naming, had taken the first step towards imposing on the wide-open pointless meaningless directionless dementia of the real a set of clichés that no one would ever dislodge, or want to dislodge – they are our human history, our edifice of thought, our answer to chaos. Eve's instinct was to bite this answer in half.

Most of us, given a choice between chaos and naming, between catastrophe and cliché, would choose naming. Most of us see this as a zero-sum game – as if there were no third place to be: something without a name is commonly thought not to exist. And here is where we may be able to discern the benevolence of the untranslatable. Translation is a practice, a strategy, or what Hölderlin calls 'a salutary gymnastics of the mind', that does seem to give us a third place to be.[12] In the presence of a word that stops itself, in that silence, one has the feeling that something has passed us and kept going, that some possibility has got free. For Hölderlin, as for Joan of Arc, this is a religious apprehension and leads to gods. Francis Bacon doesn't believe in gods but he has a profound relationship with Rembrandt.

One of his favourite paintings is a self-portrait by Rembrandt. He mentions it in several interviews. What he says he likes about this portrait is that when you go close to it you notice the eyes have no sockets. Perhaps appropriately, I have been unable to find a convincing reproduction of this portrait. It is one of Rembrandt's later darker works, you can hardly make out the contours of the face against background shadow, yet it has a strange power emanating from the socketless eyes. These eyes are not blind. They are engaged in a forceful looking, but it is not a look organized in the normal way. Seeing seems to be entering Rembrandt's eyes *from the back*. And what his look sends forward, in our direction, is a deep silence. Rather like the silence that must have followed Joan of Arc's response to the theologians when they asked her, 'In what language do your voices speak to you?' and she answered: 'In better language than yours.'

15.1 See me leaving you better hang your head and cry,
 she liked songs like that. Honkytonk influence.

16.3 All of her leapt before her eyes.

8.1 They worried about this and kept their arms close to
 the body, clasping the torso right arm below left, like
 a cummerbund.

11.6 She thought it a good idea to silence mental
 conversation.

Or like the silence that covers the final verse of a poem by Paul Celan, which will be our penultimate example of the untranslatable. It is a poem written in praise of Hölderlin and refers to the private language he sometimes spoke during the last thirty-seven years of his life when he was out of his mind or pretending to be so. It is a poem that begins in a movement toward blindness but ends with two socketless eyes that seem to be seeing perfectly well into their own catastrophic little world.

Tübingen, Jänner
Zur Blindheit über-
redete Augen.
Ihr – 'ein
Rätsel ist Rein-
entsprungenes' – , ihre
Erinnerung an
schwimmende Hölderlintürme möwen-
umschwirrt.

Besuche ertrunkener Schreiner bei
diesen
tauchenden Wörten.

Käme,
käme ein Mensch,
käme ein Mensch zur Welt heute, mit
dem Lichtbart der
Patriarchen: er dürfte,
spräch er von dieser
Zeit, er
dürfte
nur lallen und lallen,
immer-, immer-
zuzu.
('Pallaksch. Pallaksch.')

Tübingen, January
Eyes talked over
to blindness.

12.0 Clouds every one of them smell different, so do
 ocean currents. So do rocky reefs.

10.2 Her inner eye grew sharp enough to slaughter goats.

15.0 She'd been a pretty good harpist before the die-off.

6.2. So began the dinner parties.

Their – 'a
riddle is the purely
originated' -, their
memory of
swimming Hölderlintowers, gull-
whirredaround.

Visits of drowned joiners to
these
diving words:

Came,
came a man,
came a man to the world, today, with
the lightbeard of
the prophets: he could,
if he spoke of this
time, he
could
only stammer and stammer,
over-, over-
againagain.
('Pallaksch. Pallaksch.')

This poem is puzzling and dense and has provoked many
commentaries. We don't have room here for a detailed analysis
but let's focus on the riddles at the beginning and end. At the
beginning is a quotation from Hölderlin's poem 'The Rhine'
which is a hymn to the Rhine river. 'A riddle is the purely
originated' is a sentence that can be read backwards or forwards:
origin as riddle or riddle as origin. Whose origin this is, or whose
riddle, we are not exactly told. The main action of the poem is a
long conditional sentence in the subjunctive – maybe contrafactual
maybe not – that seems to lament the powerlessness of language
to speak of the times in which we live. A man who chose to
struggle with this inadequacy – a prophet or a poet – would be
reduced to stammering the same word over and over. Or perhaps
further reduced to stammering something that is not quite a word.

10.0 Eventually the Cycladic people died out all except one, a ferryboat captain.

8.2 Left arm below right was considered uncouth.

7.0 To play a stringless harp requires only the thumbs.

5.0 The Cycladic people were very fond of Proust.

According to people who visited him in his tower, Hölderlin invented the term 'Pallaksch' and used it to mean sometimes Yes sometimes No. A useful term in that case. Poets are always coming up with these useful terms, they invent neologisms or use existing words in new, strange, and inventive ways. Of course linguistic invention is a risk. Because it comes across as a riddle and it poses the problem of pure origin: you cannot get behind the back of it, any more than you can find the source of the Rhine or see the sockets in Rembrandt's eyes or know the meaning of the gods' word Μῶλυ (*mōlu*). 'Pallaksch Pallaksch' has to stand as its own clue, has to remain untranslated. Paul Celan places it within brackets as if he were closing the doors of his poem upon this silence.

To sum up. Honestly, I am not very good at summing up. The best I can do is offer a final splatter of white paint. As a classicist I was trained to strive for exactness and to believe that rigorous knowledge of the world without any residue is possible for us. This residue, which does not exist – just to think of it refreshes me. To think of its position, how it shares its position with drenched layers of nothing, to think of its motion, how it can never stop moving because I am in motion with it, to think of its shadow, which is cast by nothing and so has no death in it (or very little) – to think of these things gives me a sensation of getting free. Let us share this sensation. What follows is an exercise, not exactly an exercise in translating, nor even an exercise in untranslating, more like a catastrophizing of translation. I shall take a small fragment of ancient Greek lyric poetry and translate it over and over again using the wrong words. A sort of stammering.

4.3 Is it because you don't want the impact.

11.2 In the pantry she sat at the counter and ate with
 her hands.

16.0 As far as the experience of stirring is concerned,
 small stillness produces small stirring and great
 stillness great stirring.

Ibykos, 6th century BC, known for his love of boys, love of girls, love of adjectives and adverbs, and pessimism.

[Ibykos fr. 286]

ἦρι μὲν αἵ τε Κυδώνιαι
μηλίδες ἀρδόμεναι ῥοᾶν
ἐκ ποταμῶν, ἵνα Παρθένων
κῆπος ἀκήρατος, αἵ τ' οἰνανθίδες
αὐξόμεναι σκιεροῖσιν ὑφ' ἕρνεσιν
οἰναρέοις θαλέθοισιν· ἐμοὶ δ' Ἔρως
οὐδεμίαν κατάκοιτος ὥραν.
†τε† ὑπὸ στεροπᾶς φλέγων
Θρηίκιος Βορέας
ἀίσσων παρὰ Κύπριδος ἀζαλέ-
αις μανίαισιν ἐρεμνὸς ἀθαμβὴς
ἐγκρατέως πεδόθεν †τινάσσει†
ἡμετέρας φρένας

In spring, on the one hand,
the Kydonian apples trees,
being watered by streams of rivers
where the uncut garden of the maidens [is]
and vine blossoms
swelling
beneath shady vine branches
bloom.
On the other hand, for me
Eros lies quiet at no season.
Nay rather,
like a Thracian north wind
ablaze with lightning,
rushing from Aphrodite
accompanied by parching madnesses,
black,
unastonishable,
powerfully,
right up from the bottom of my feet
[it] shakes my whole breathing being.

[Ibykos fr. 286 translated using only words
from 'Woman's Constancy' by John Donne]

In woman, on the one hand,
those contracts
being purposed by change and falsehood,
where lovers' images [forswear the persons that we were],
and true deaths
sleeping
beneath true marriages,
antedate.
On the other hand, me
thy vow hast not conquered.
Nay rather,
like that new-made Tomorrow,
now disputing,
now abstaining,
accompanied by Love and his wrath,
truly,
not truly,
if I would,
if I could,
[it] justifies my one whole lunatic escape.

[Ibykos fr. 286 translated using only words
from Bertolt Brecht's FBI file #100-67077]

At a cocktail party attended by known Communists, on the
 one hand,
the subject
being suitably paraphrased as Mr & Mrs Bert Brecht,
where ten years of exile have left their mark,
and beneath 5 copies of file 100-190707,
Charles Laughton
returning to the stage as Galileo,
enters an elevator.
On the other hand, of my name with a hyphen between
 Eugene and Friedrich
the Bureau has no record.
Nay rather,
like the name of a certain Frenchman to whom Charles
 Laughton might send packages,
accompanied by an unknown woman
who spoke to an unknown man,
or accompanied by an unknown man
who spoke to an unknown woman,
and in the event that all the captions are not correct,
please turn to page 307.

[Ibykos fr. 286 translated using only words
from p. 47 of *Endgame* by Samuel Beckett]

In your kitchen, on the one hand,
bright corpses
starting to stink of having an idea,
where one of my legs [is]
and beneath sooner or later
the whole universe
doesn't ring and won't work.
On the other hand, I shouldn't think so.
Nay rather,
like a speck in the void,
pacing to and fro,
accompanied by the alarm,
frankly,
angrily,
impatiently,
not very convinced,
[it] kisses me goodbye. I'm dead. (Pause).

[Ibykos fr. 286 translated using only words from
Conversations with Kafka by Gustav Janouch, pp. 136-7]

In the end, on the one hand, all those who sit behind us at
 the cash desks,
being engaged in the most destructive and hopeless
 rebellion there could ever be,
where everything human [has been betrayed]
and
beneath the burden of existence
stock phrases,
with a gentle indefinable smile,
arouse suspicion.
On the other hand,
one who is afraid should not go into the wood.
Nay rather,
like modern armies,
accompanied by lightly spoken phrases in Czech
 or German,
fearlessly,
patiently,
unfortunately,
against myself,
against my own limitations and apathy,
against this very desk and chair I'm sitting in,
the charge is clear: one is condemned to life not death.

[Ibykos fr. 286 translated using stops and signs from
the London Underground]

At the excess fare window, on the one hand, the king's bakers,
ditching old shepherds for new elephants,
where east and west [cross north]
and beneath black friars forbidden from barking in church,
angels
mind the gap.
On the other hand,
a multi-ride ticket does not send me padding southwark.
Nay rather, like the seven sisters
gardening in the British Museum,
accompanied by penalties,
tooting,
turnpiked,
hackneyed,
Kentish,
cockfostered,
I am advised to expect delays all the way to the loo.

[Ibykos fr. 286 translated using only words from *The Owner's Manual* of my new Emerson 1000w microwave oven, pp. 17-18]

In hot snacks and appetizers, on the one hand, the soy,
 barbecue, Worcestershire or steak sauce,
being sprinkled with paprika,
where a 'browned appearance' [is desirable]
and beneath the magnetron tube
soggy crackers,
wrapped in bacon,
toughen.
On the other hand, a frozen pancake
will not crust.
Nay rather,
like radio waves,
bubbling,
spattering,
accompanied by you rubbing your hands together,
 without venting the plastic wrap,
 without rearranging the pieces halfway through,
 without using the special microwave popper,
 [it] will burn your nose right off.

Notes

1 David Sylvester, *The Brutality of Fact: Interviews with Francis Bacon*, 48.

2 M. Peppiatt, 'Interview with Fancis Bacon', *Art International* 8, 1989, 43-57.

3 See F. Meltzer, *For Fear of the Fire*, 124.

4 H. Davies, 'Interview with Francis Bacon', *Art in America* 63, 1975, 62-68.

5 Cited in Christophe Domino: *Francis Bacon: Painter of a Dark Vision*, trans. R. Sharman, 1997, 6.

6 David Sylvester, *The Brutality of Fact*, 174-5.

7 David Constantine, *Hölderlin's Sophocles*, 8-11.

8 In Eric Santner (ed.), *Friedrich Hölderlin: Hyperion and Selected Poems*, xxix.

9 David Constantine, *Hölderlin*, 116-117, 381.

10 Aris Fioretos, *The Solid Letter: Readings of Friedrich Hölderlin*, 277.

11 David Sylvester, *The Brutality of Fact*, 94.

12 David Constantine, *Hölderlin's Sophocles*, 7.

COLOPHON

THE CAHIERS SERIES · NUMBER 21
ISBN: 978-1-90963103-8

Printed by Principal Colour, Paddock Wood,
on Neptune Unique (text) and Chagall (dust
jacket). Typeset by Sylph Editions in Giovanni
Mardersteig's Monotype Dante.

With grateful thanks to Marie Donnelly for
her generous support.

Series Editor: Dan Gunn
Associate Series Editor: Daniel Medin

CENTER FOR WRITERS & TRANSLATORS
THE AMERICAN UNIVERSITY OF PARIS

SYLPH EDITIONS, LONDON | 2013

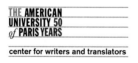

center for writers and translators

SYLPH
EDITIONS

www.aup.edu · www.sylpheditions.com